AFRICAN GOLD ORNAMENT DESIGNS

DIANE VICTORIA HORN

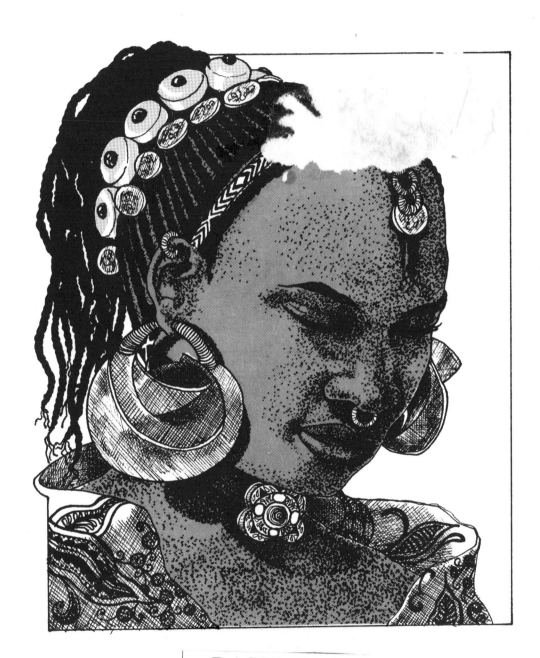

Stemmer

INTRODUCTION

GOLD HAS BEEN USED SINCE ANTIQUITY by many provinces and rulers throughout the vast continent of Africa. North Africans held the belief that the shining substance helped to avert the influence of the "evil eye." In West Africa, the ownership of gold was used by royalty to display prestige and power and the African goldsmith created objects of great beauty with astoundingly sophisticated craftsmanship. Many Royal African families preserved a legacy of gold objects inherited from their ancestors and exhibited during special ceremonies.

For example, the Kingdom of Asante, in the modern state of Ghana, rose to power in the eighteenth century under Asantahene (King) Osei Tutu. To strengthen the power of Asante, he and his chief priest revised the constitution, deliberately using gold regalia as constitutional symbols. Until his time the royal wooden throne symbolized the individual ruler. Osei Tutu substituted a special Golden Stool that was said to have descended from heaven onto his lap, symbolizing the Asante nation. When a ruler died, the nation would live on in the Golden Stool. A ceremony held every year to glorify the Asante nation reinforces the national identity of its people. The Golden Stool is hung with gold death masks of generals defeated by Asante armies. It is carried in procession for all to see and placed on a special platform, without ever touching the ground. Royal power is further manifested in the proliferation of gold regalia worn and used by the Asantahene and his subordinate chiefs, devised as symbols of their political status. Shielded from the sun by vast umbrellas which are topped by gold-plated insignia with symbolic meanings, the people in the royal procession are covered with golden ornaments. The golden crowns, breastplates, jewelry and sandals are worked with elaborate designs conveying an overwhelming sense of opulence, dignity and supernatural authority. In spite of customs like this, old gold objects have rarely survived, for a number of reasons. When gold objects were damaged or considered unfashionable, they were usually recycled. Antique objects were traded, lost in warfare or, if placed in royal burial sites, were often ransacked by archeologists and grave robbers.

Gold has been found scattered widely in quartz reefs, sands and river gravels in the forests and savannah of West Africa, and was readily mined in major fields for at least 1,000 years. Most of the gold used in the ancient pyramids of Egypt was imported from the African interior. Although archaeologists have found ancient castings including brass weights, gold jewelry and "fetish" ornaments, the study of African gold objects is still in its infancy. Early documented evidence of goldsmithing is scanty before the fifteenth century when Europeans penetrated the African interior.

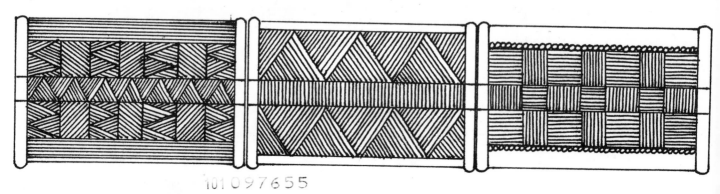

Goldsmithing probably originated when groups established chieftains who, in turn, employed goldsmiths in their royal courts. Blacksmiths and goldsmiths were one and the same, working with brass, copper, silver and aluminum as well as with gold. West African blacksmiths had worked with metals since the first millenium B.C. When trans-Saharan trade began, people of the Sahara came in contact with North Africans and adopted their techniques of goldsmithing and silversmithing. These techniques, such as filigree, granulating and lost-wax casting spread rapidly throughout West Africa and goldsmithing became a specialized craft. North African goldsmiths also moved to the Sahel to make, sell and trade their wares, while West Africans studied as apprentices of the craft. The art of goldsmithing quickly spread throughout West Africa and was employed to produce royal regalia, weapons, horse-trappings and jewelry. The antique gold ornaments were at first fashioned in traditional West African designs, but foreign contact began to influence the customer's demands strongly. Some of the designs were imported from the Middle East, Portugal, Spain and Europe. However, external influence was less evident further south of the Sahara.

Many average African people preserved their gold ornaments as cherished fineries. African women were passionate about gold jewelry, though many preferred silver. Those who could afford gold adorned themselves from head to toe. Rings were the most commonly embellished forms of jewelry, followed by earrings, nose rings, hair ornaments accompanied by elaborate coiffures, necklaces, chains, pendants, arm rings, anklets and toe rings. Breastplates or pectoral discs were often worn by men of many regions as badges of rank. The discs sometimes displayed the ruler's insignia, and the glistening gold plates were generally worn as charms thought to protect the wearer against the influence of evil. In some regions, large, flat disc-shaped beads were presented by suitors to their betrothed to secure their hands in marriage.

Human face pendants appear to be those of males, often decorated with beards, small moustaches, elaborate coiffures and facial scarifications. They were worn attached to caps, in the hair or as necklaces by both males and females either during festive occasions or as objects of beauty and prestige. They were also used as goldweights. In some regions the face pendants represented ancestral "portraits" owned by royalty. In other areas the portrait pendants were intended to stylistically represent "trophy heads" of enemies slain by chiefs in battle. Elsewhere, they were owned by anyone rich enough to afford them, and were considered family heirlooms passed from one generation to the next.

Other pendants were images of animals resembling the sawfish, crocodile, tortoise, turtle, mudfish, python, frog, snail, bushcow, elephant, leopard, antelope, chicken, crab, horned ram's head and even the human hand. Some pendants were referred to as "fetish" ornaments believed to possess protective powers. In the lagoons region, a rich man seeking to consolidate his prestige would exhibit publicly his accumulated treasure of gold pendants, producing a spectacular public display of gold. By holding a successful exhibition a man raised his status, joined the ranks of respected elders in his community and proved himself worthy of his ancestors.

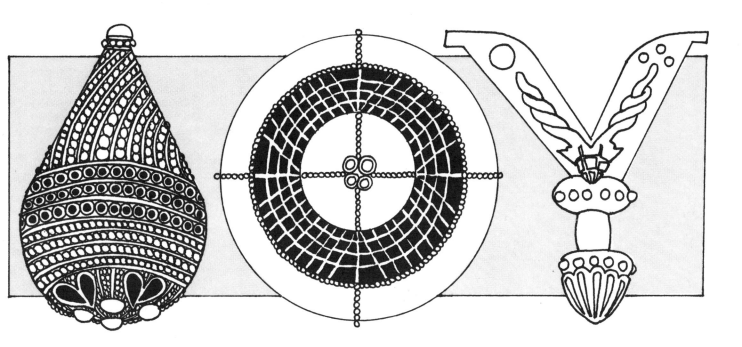

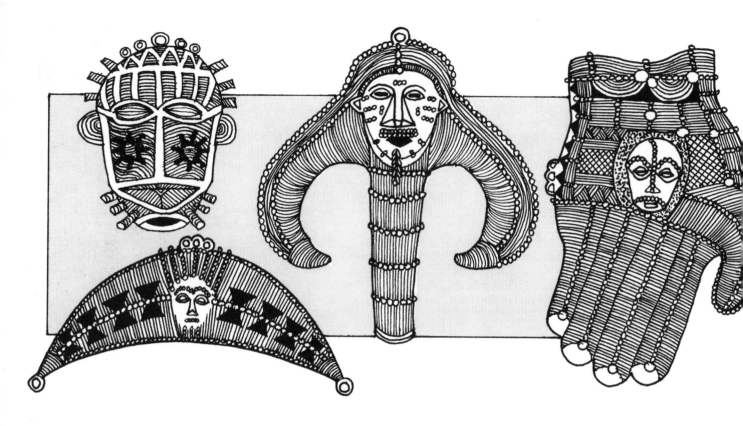

Generally, gold objects possessed a certain "workshop style," but cannot be identified accurately along ethnic lines. However, the most widely known African gold ornaments were produced by the Akan of West Africa. First discovered by Europeans in the fifteenth century, the 300 mile coastal region of Ghana became known as the Gold Coast for its abundance of gold dust, nuggets and worked jewelry. Centuries before European contact, the Akan had traded gold for brass and copper with people as far away as North Africa, Egypt and the Middle East, and the form and decorative motifs were strongly influenced by the Islamic world. By the sixteenth century, the magnificent work produced by the Akan goldsmiths was admired and sought after by the Portuguese, English and Dutch merchants alike. Akan goldwork far surpassed the skills and the craftsmanship of any found in Europe. The Akans used lost-wax castings to produce numerous delicate objects, such as small utensils, beads, rings, chains, stools, crowns, toothpicks, headbands, sword hilts, breastplates, helmets, sandals, bracelets, hunting horns, necklaces, pendants, boxes, scales, talismans, weights, animal figures and even filigree bird's eggs. Fanciful names were often attributed to bead types, such as "the setting sun," "the slaves's toe," "a pool of water," "corn stalk," "chicken feather," "bamboo door," "knife handle" and "back of the tortoise." Most Akan gold rings displayed a wealth of proverbial imagery, such as animals, birds, fish, insects, fruit, seeds and man-made artifacts. Each of these motifs conveyed a message to the beholder. The use of proverbial designs was exactly paralleled in Akan goldweights.

Akan gold beadwork, however, was purely abstract and geometric, often made of openwork designs resembling filigree. Discs and spirals were the most common shaped beads along with rectangles, diamond-shaped, tubes and conicals. Many of the same shapes can be found throughout North and West Africa. It is common to find beads that are basically simple abstract and geometric forms, such as discs and bicones. But it is just as common to find other gold jewelry forms and ornaments that represent tusks, horns, claws, leopard's teeth, seeds, shells, drums, stars and stools.

Goldsmiths used a variety of techniques to create ornaments and jewelry. The following illustrations demonstrate the basic techniques of hammering, cutting, gold leaf, lost-wax casting, hollow casting and filigree.

GOLDSMITHING TECHNIQUES

(See illustrations on page 6)

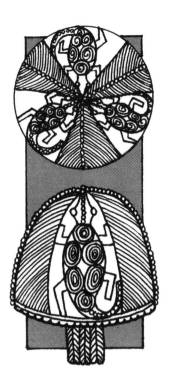

A. Hammering
1. gold pellet
2. hammered pellet
3. trimmed
4. heated and bent

B. Hammering
1. gold rod
2. heated and hammered over anvil to desired form
3. hammered earring

C. Hammered and embossed disc-shaped pectoral

D. Decorative Techinque: Gold Leaf
A pellet of gold is hammered to a very thin sheet, then molded and glued or stapled to the surface of a carved wooden ornament.

E. Lost-Wax Casting
Solid wax model made of object to be cast. Wax mold invested with one or more coats of slip made from pulverized charcoal and clay. Wax model encased in a clay mold. Mold is heated over a pot of water; molten wax drains through a small duct. Molten gold is poured into mold filling the cavity.

F. Openwork Casting
Wax threads are molded over a wax skin core made from a mixture of clay and charcoal. Threads arranged in lattice-work, spirals or other open designs. The core is removed after casting.

G, H. Wirework and Filigree
1. Iron drawplate
2. Wires are drawn through successively finer holes until reduced to desired diameter.
3. Wires then twisted to achieve filigree design and then soldered.

In contemporary Africa, there is a substantial decline of high quality hand-crafted goldwork. Large ethnic groups that once lived in pastoral villages now reside in bustling metropolises where there is less demand for ornate gold regalia and jewelry. Royal regalia is no longer needed as much as in past centuries, and traditional forms of jewelry are now produced with imported chemicals, tools, appliances, gilding and electroplating. Traditional designs are copied from pattern books and mass-produced to meet the demands of an international clientele. The art of the African goldsmith, while now technically competent, has lost the beauty and originality of hand-craftsmanship. The few rare examples that have withstood the test of time maintain the magnificence of design and superb craftsmanship. This book is intended to act as a portfolio of traditional African gold designs, recorded in detail and preserving the ideas employed by great master craftsmen who created them during the glorious past of Africa.

D.V.H.

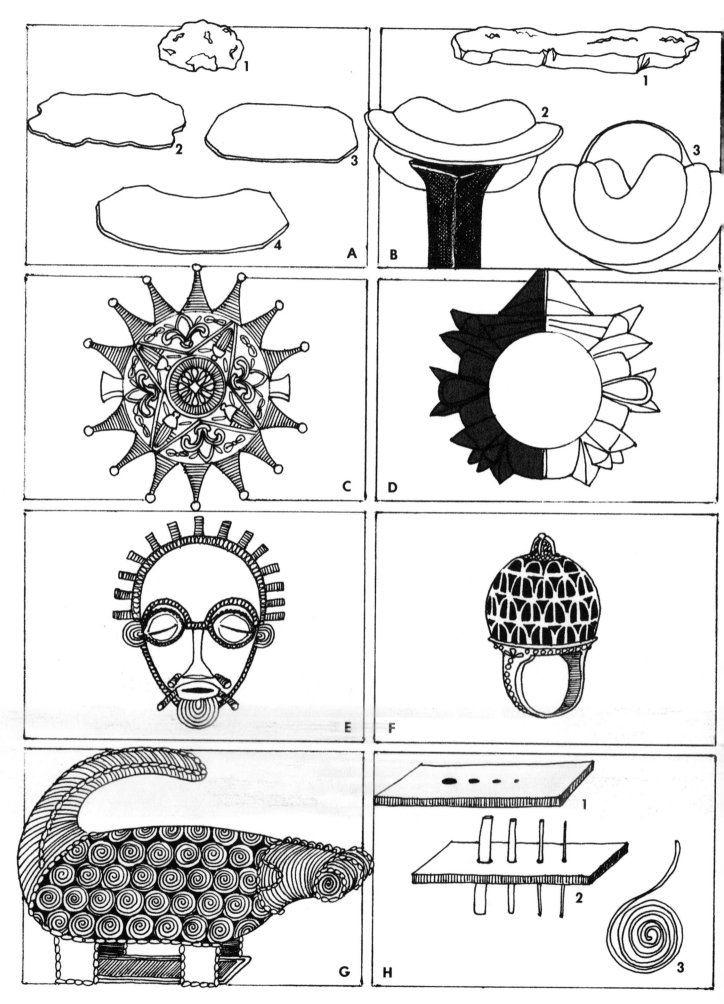

BIBLIOGRAPHY

Angela Fisher. *Africa Adorned.* New York: Harry N. Abrams, Inc., Publishers, 1984.
Jocelyn Murray, Editor. *Cultural Atlas of Africa.* New York: Facts on File, Inc., 1985.
Timothy Gerrard. *Gold of Africa: Jewellery and Ornaments from Ghana, Cote d'Ivoire, Mali and Senegal.* Munich: Prestel-Verlag, 1989.
Marion Van Offelen. *Nomads of Niger.* New York: Harry N. Abrams, Inc., Publishers, 1983.

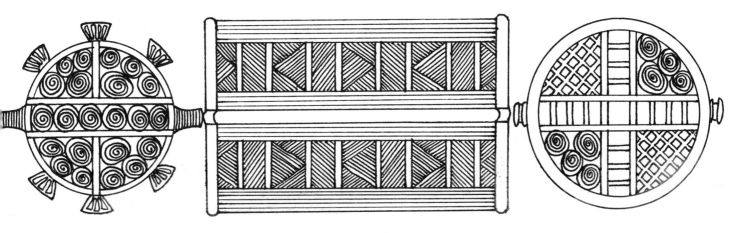

This book is dedicated to my parents, Carrie and Lewis Horn.

ILLUSTRATIONS

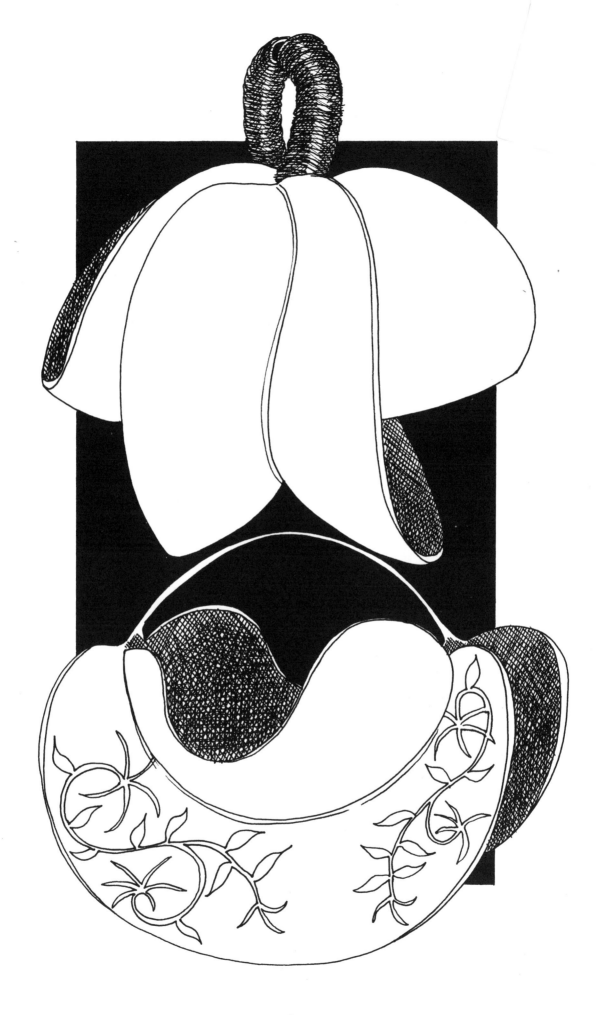

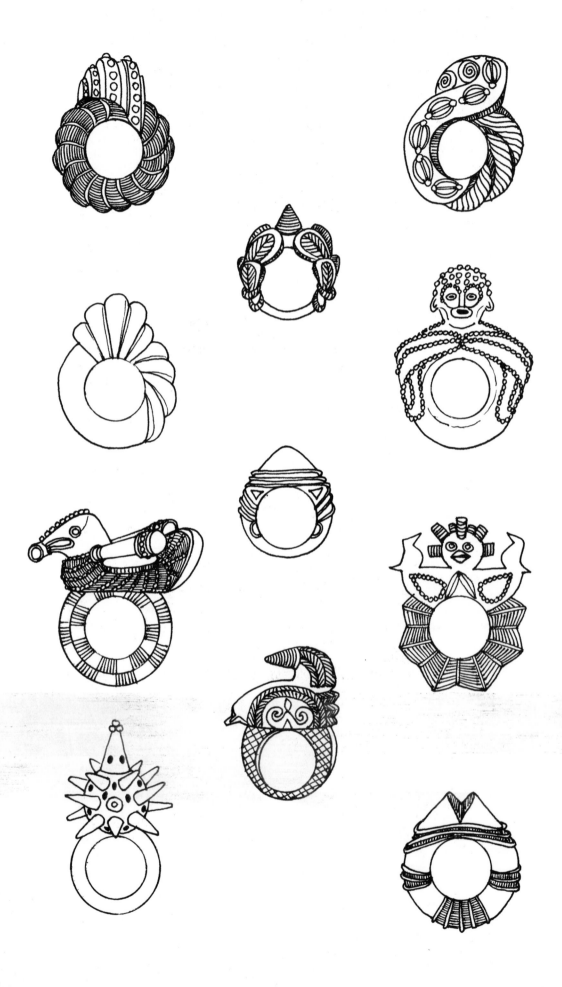

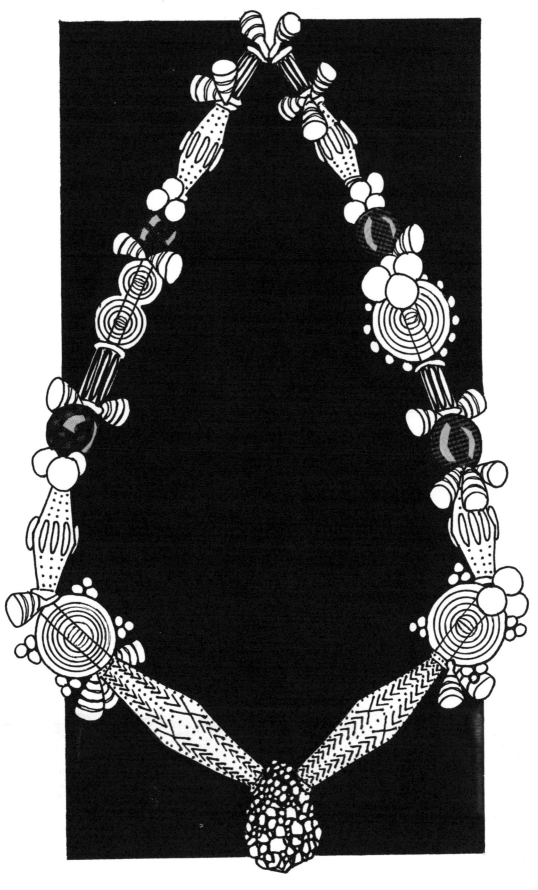

 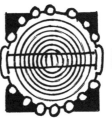 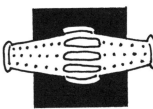

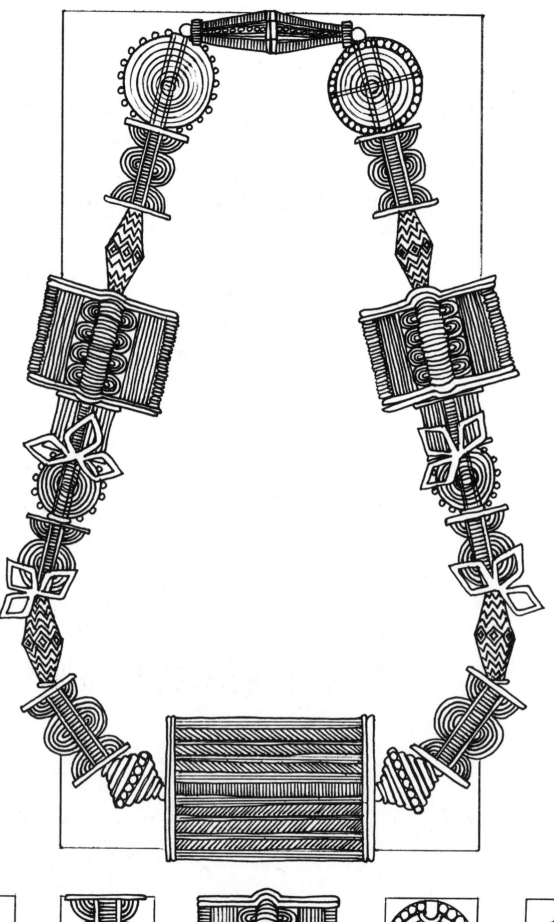

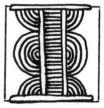
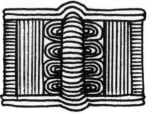
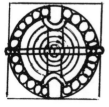
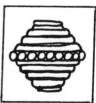

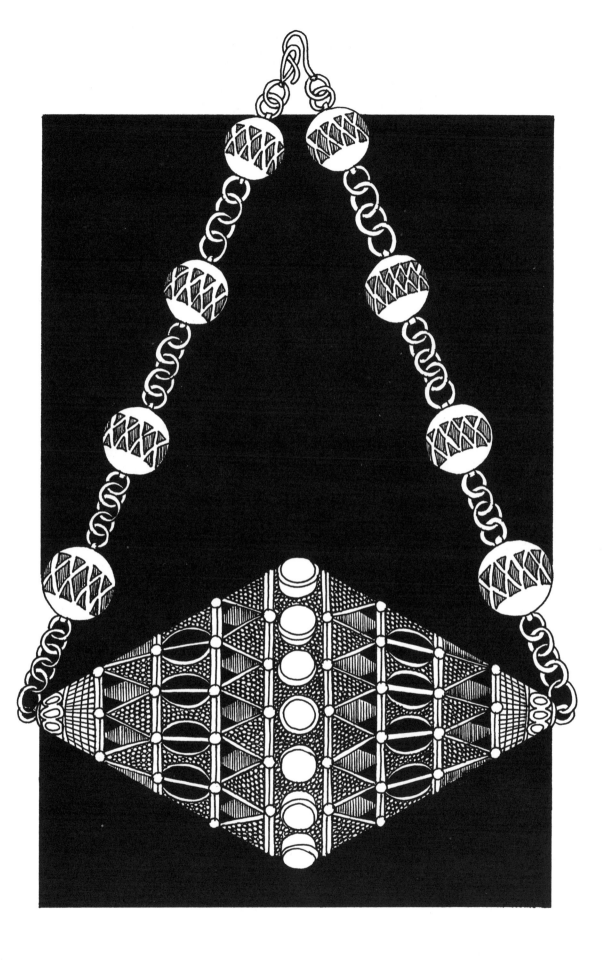

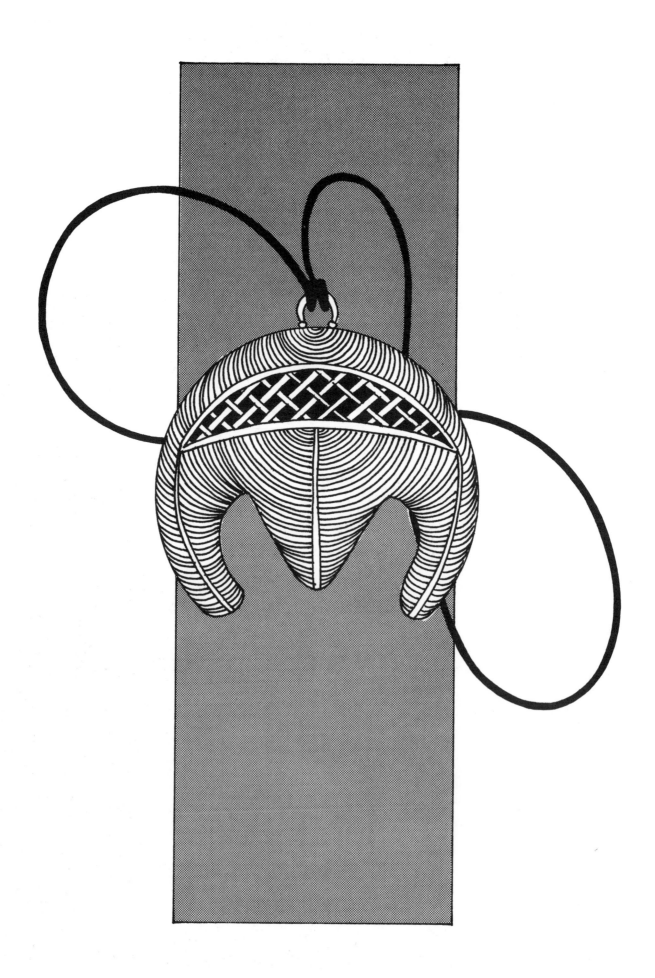

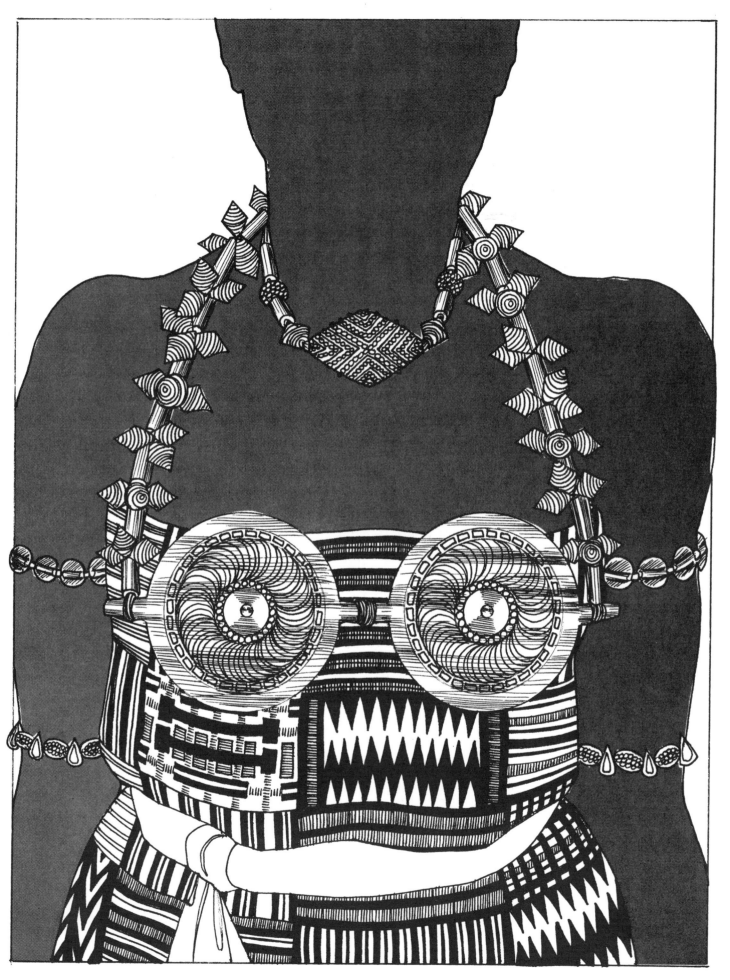

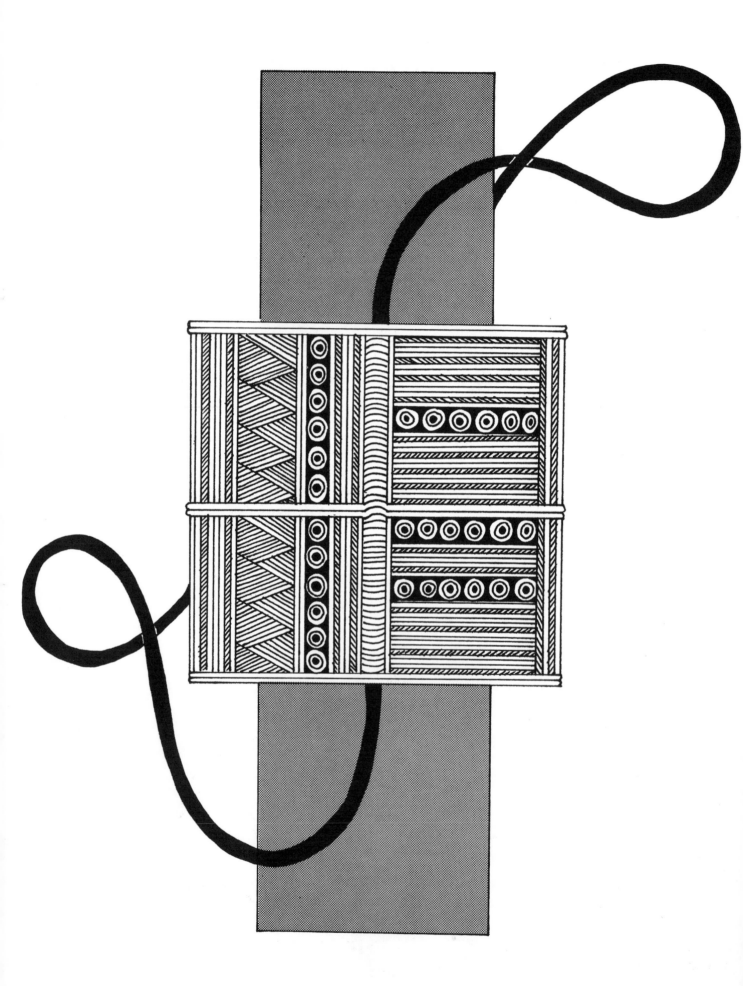

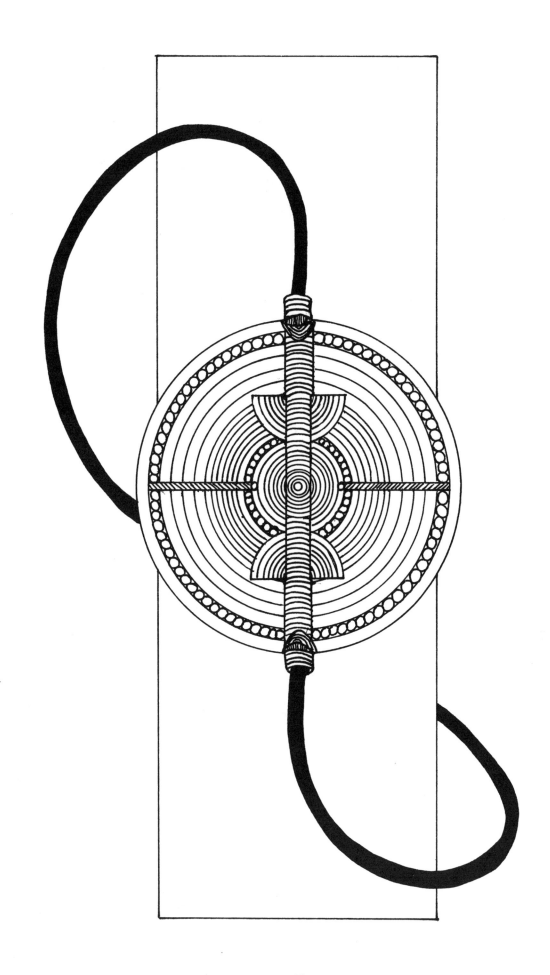

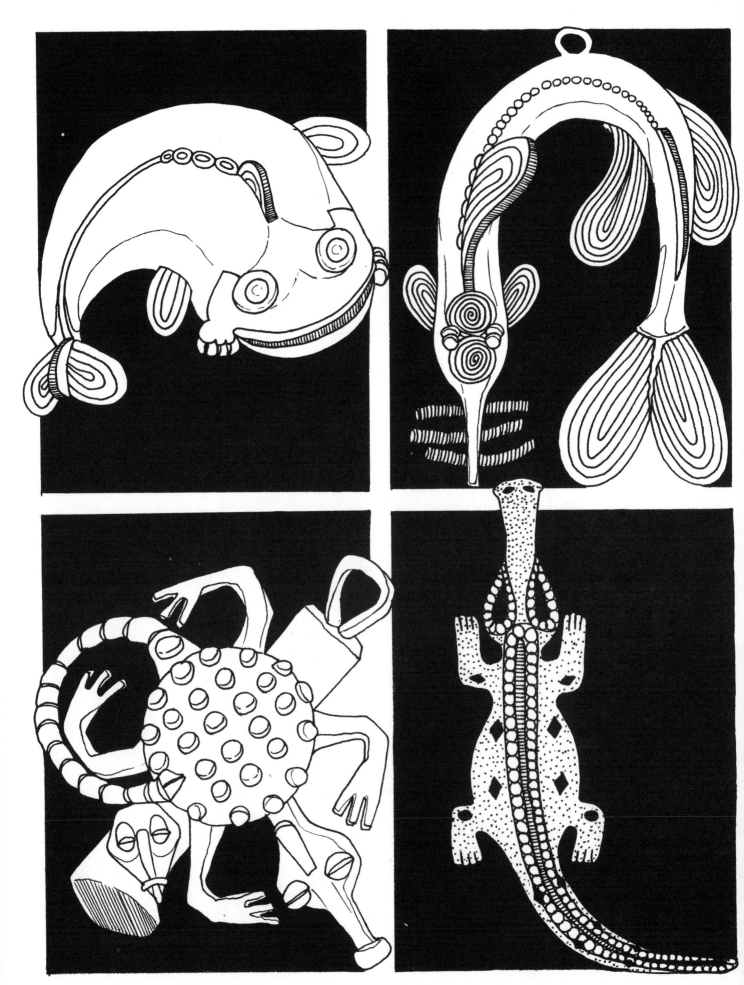

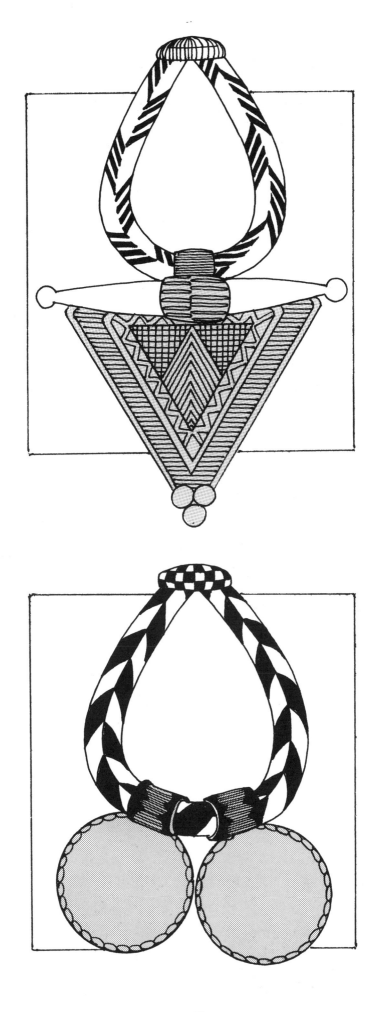

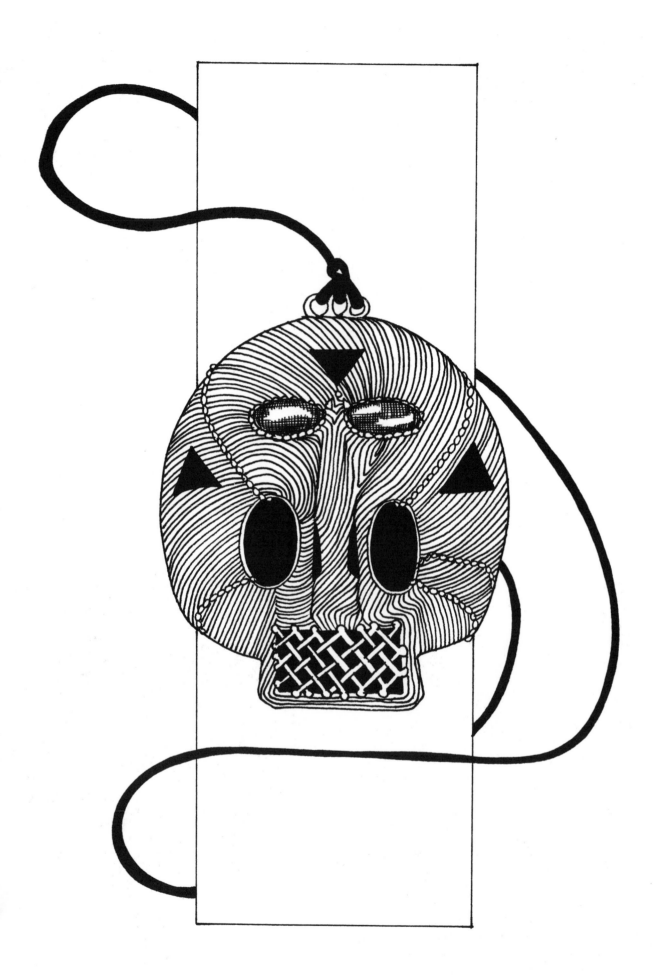

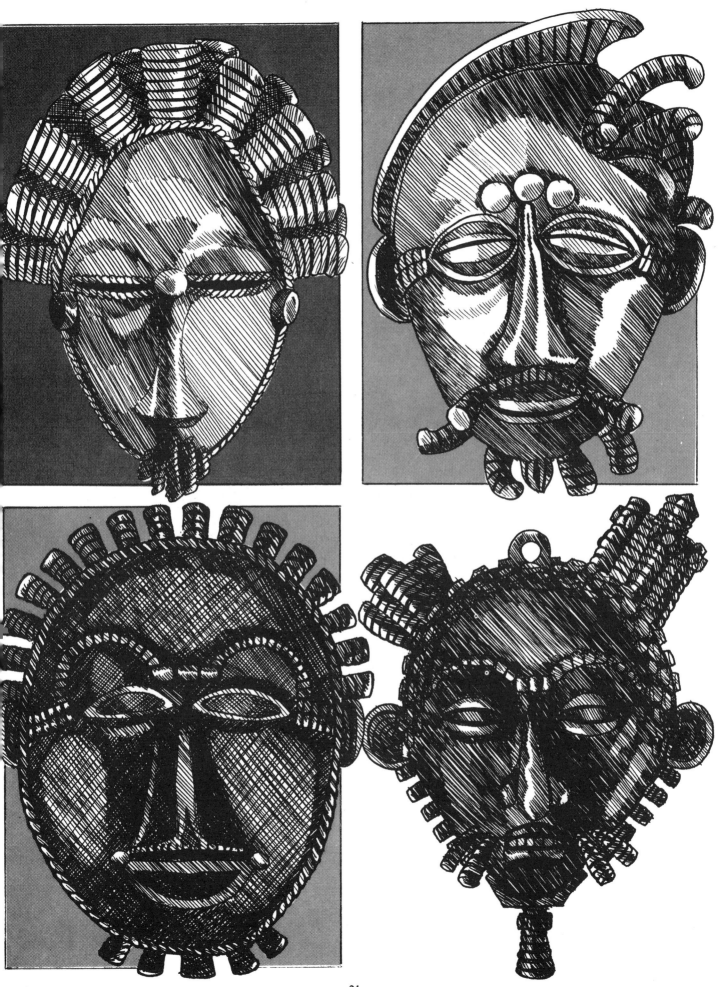

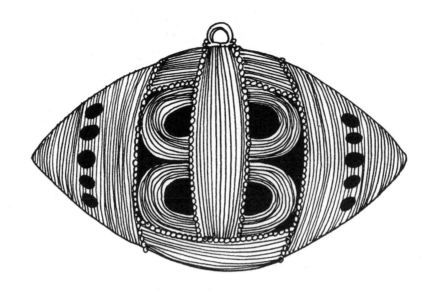

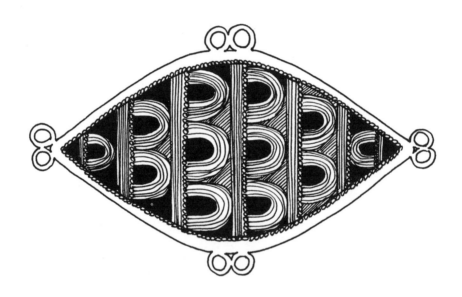

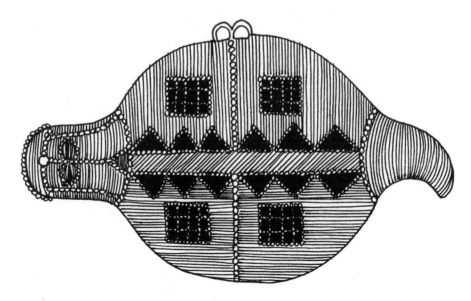

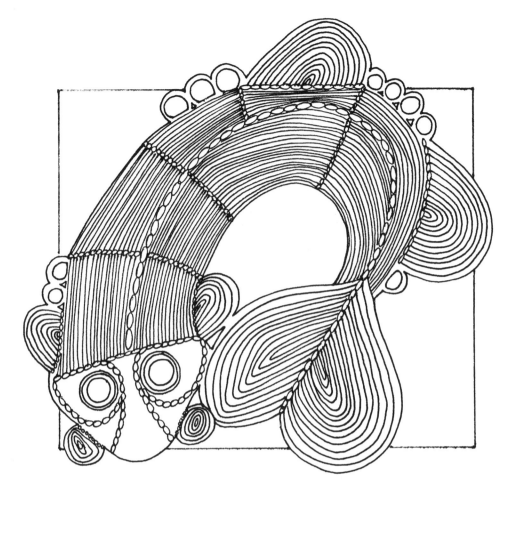

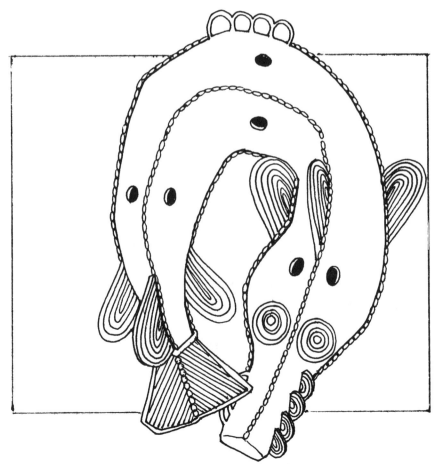

23

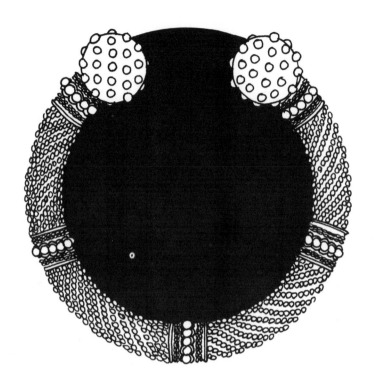

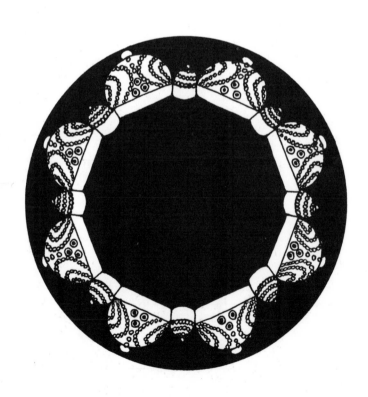

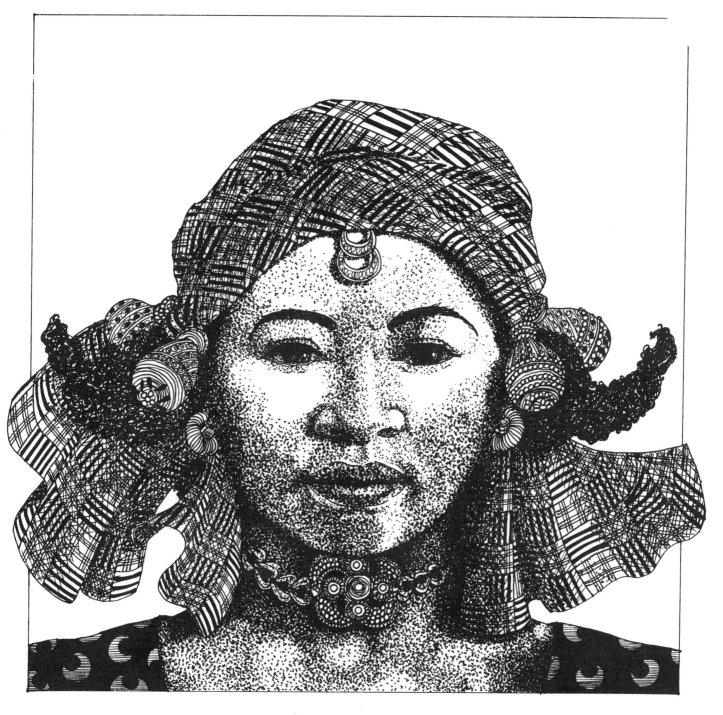

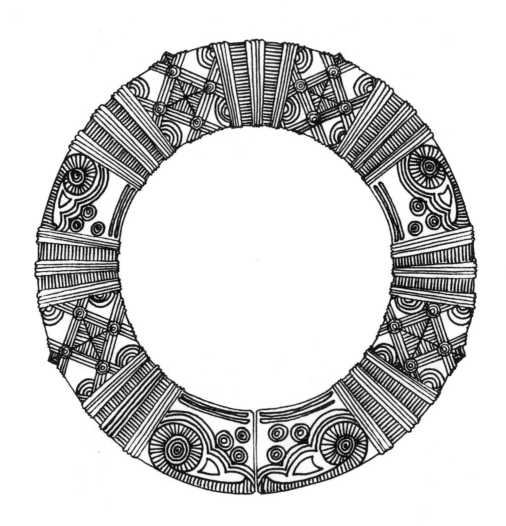

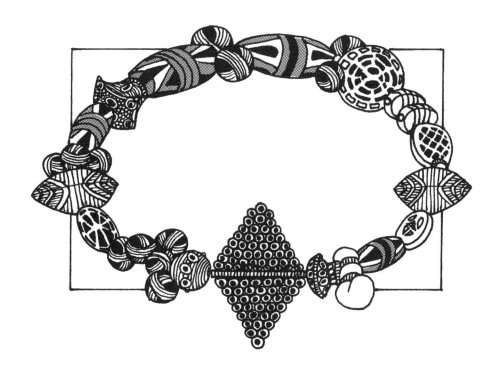

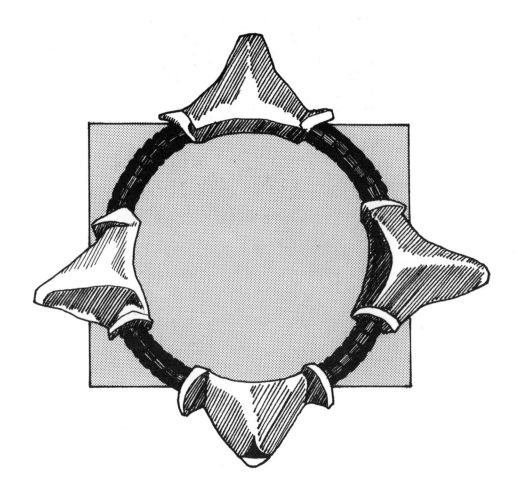

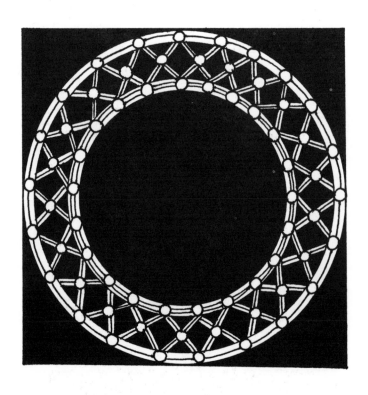

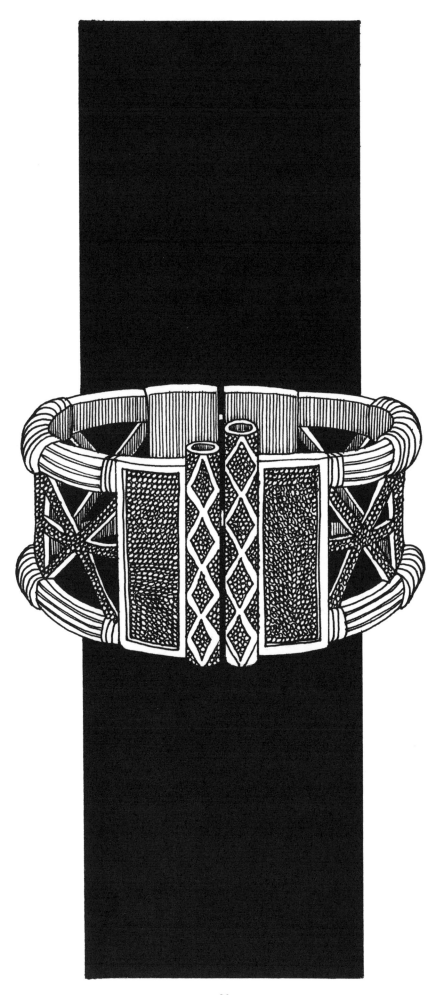

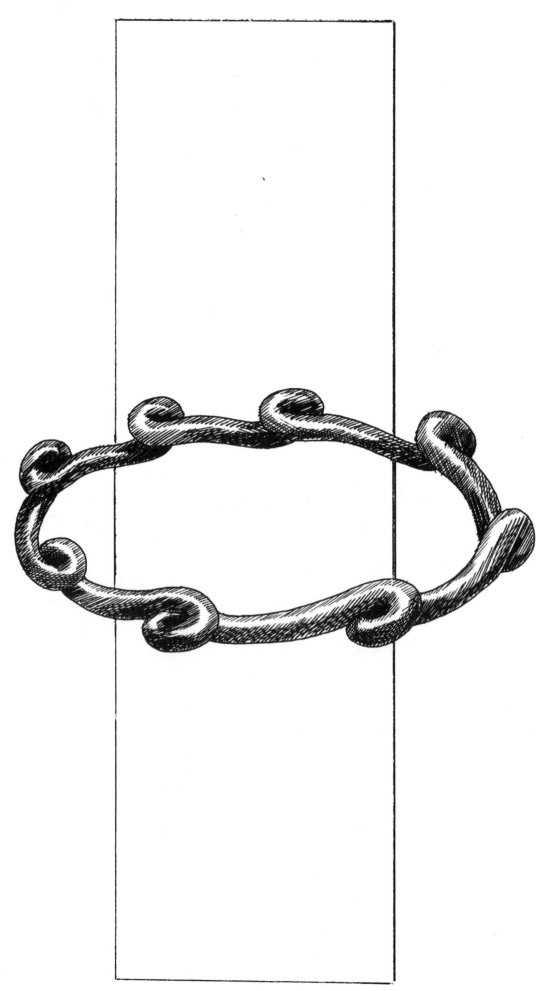

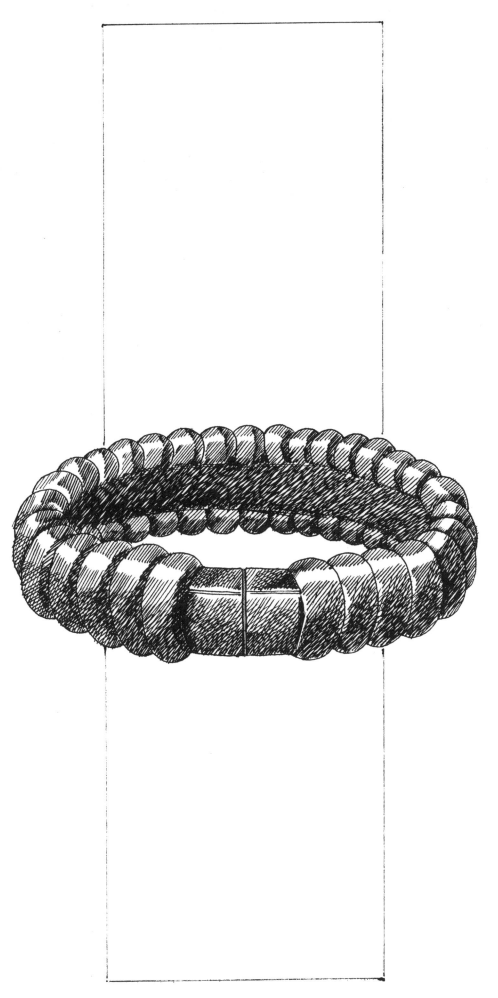

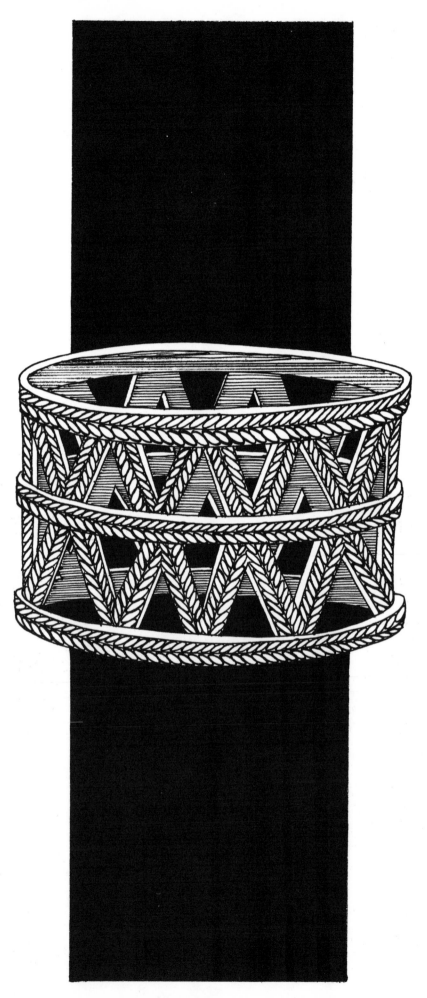

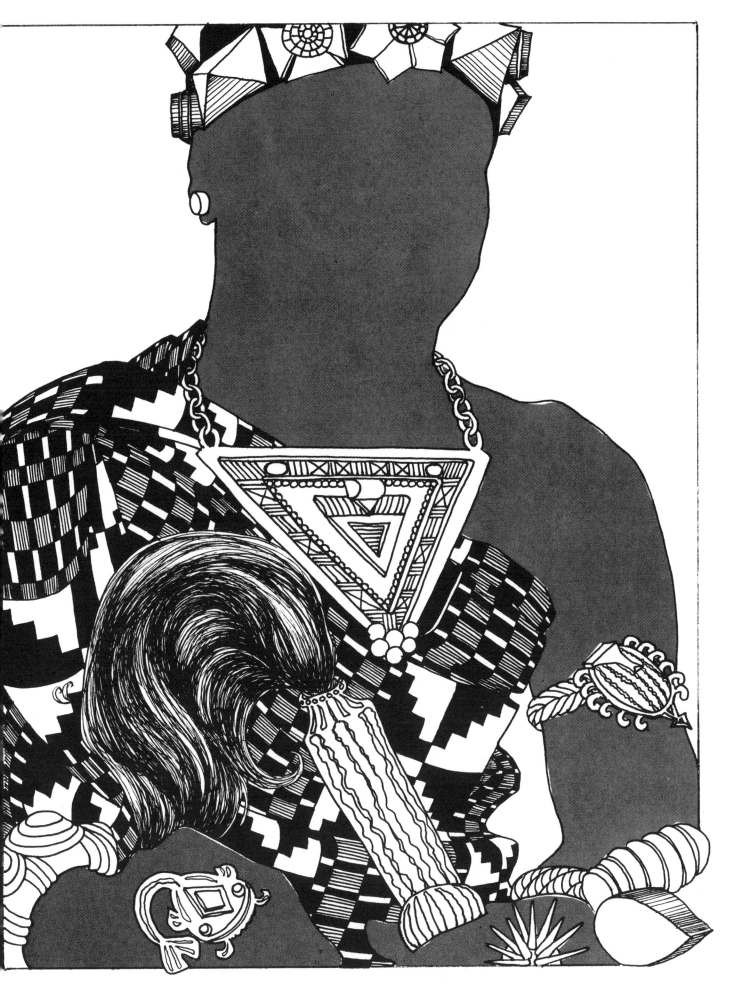

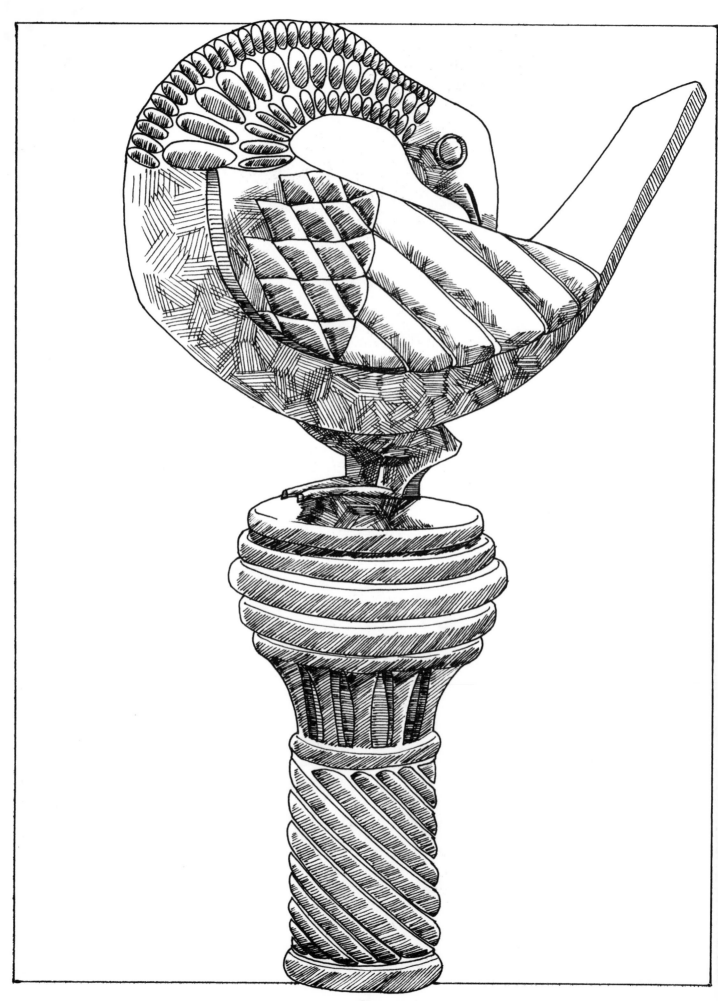

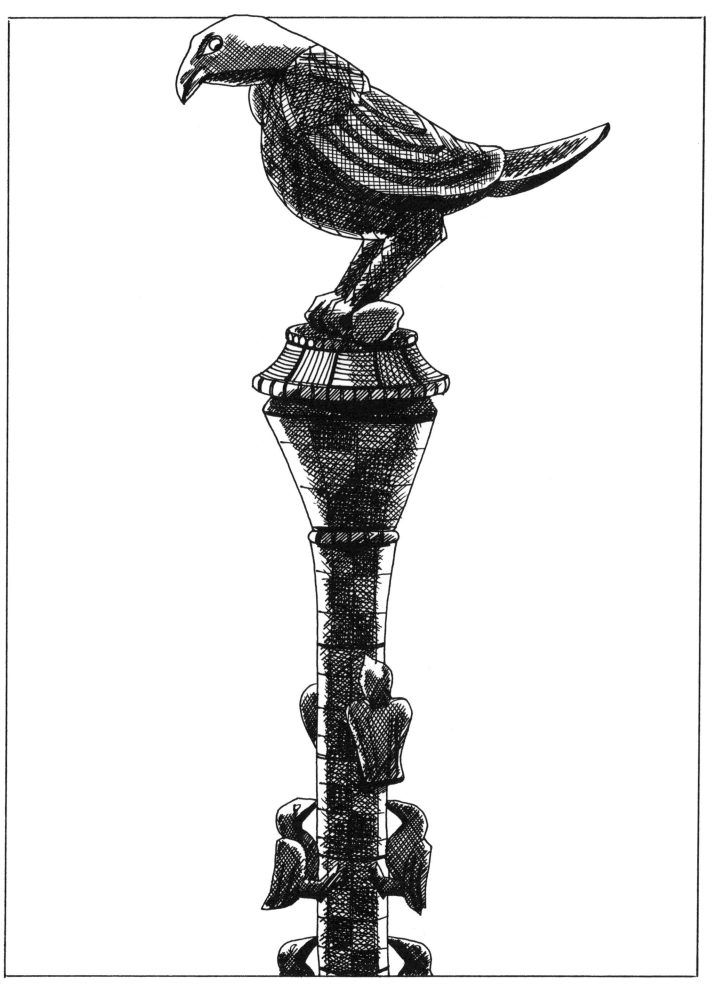

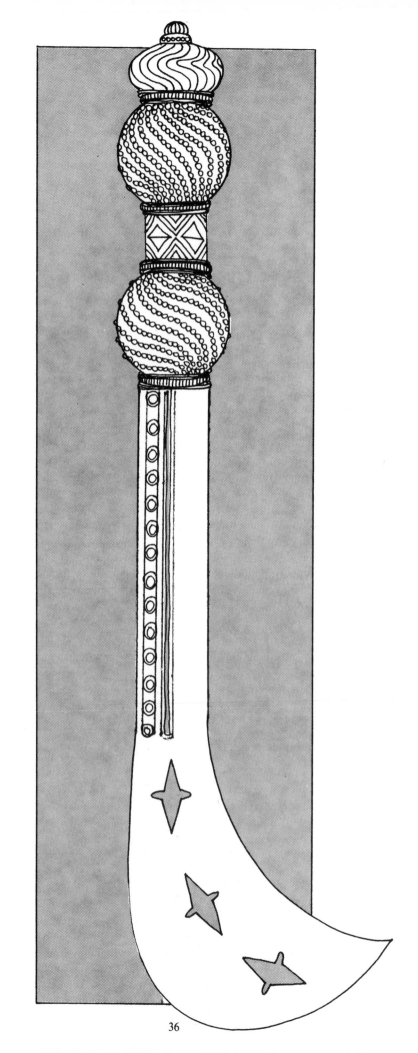

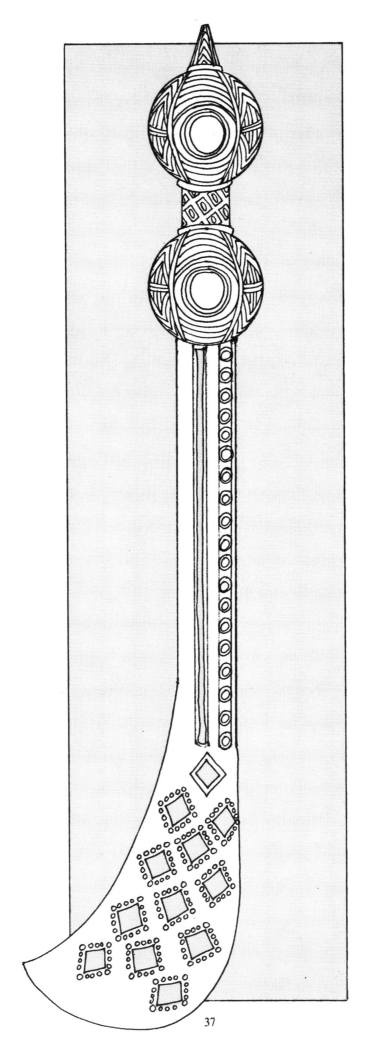

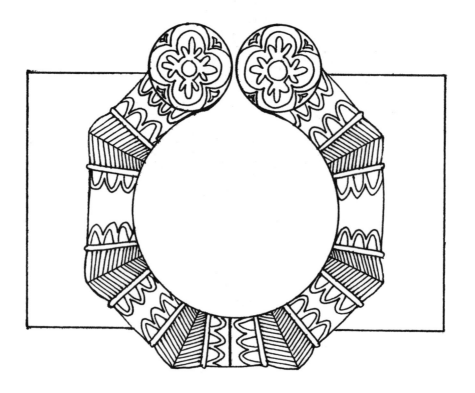

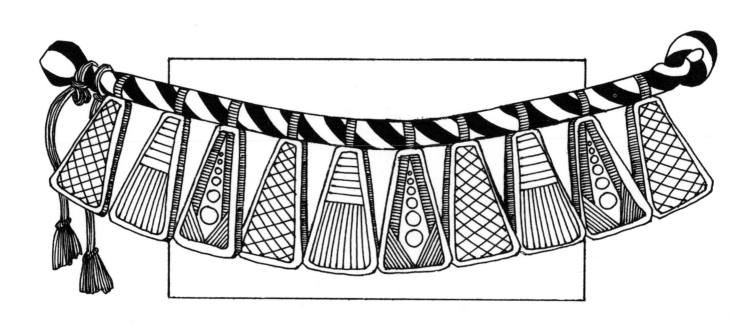

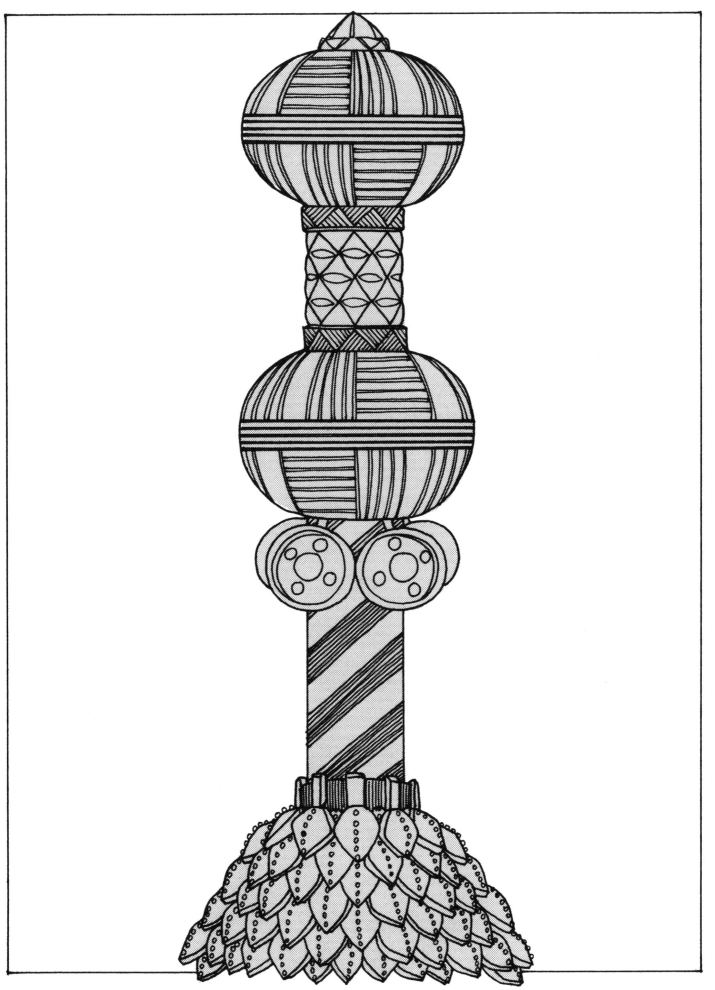

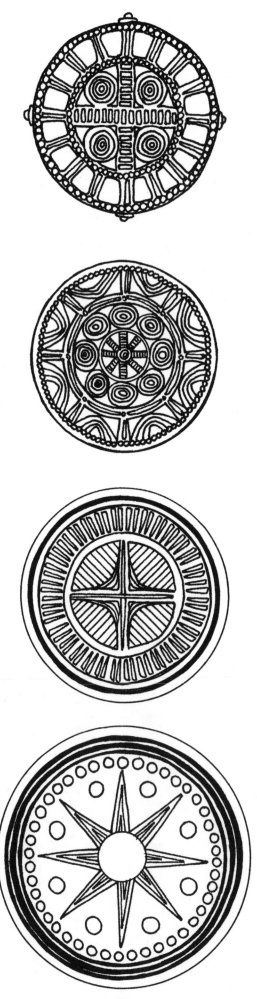

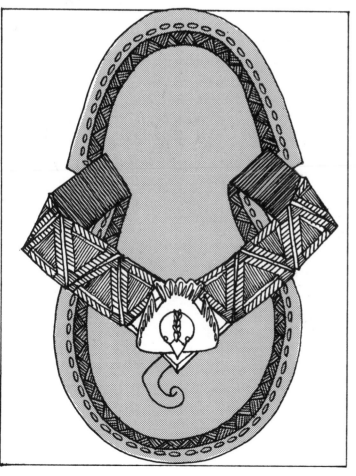

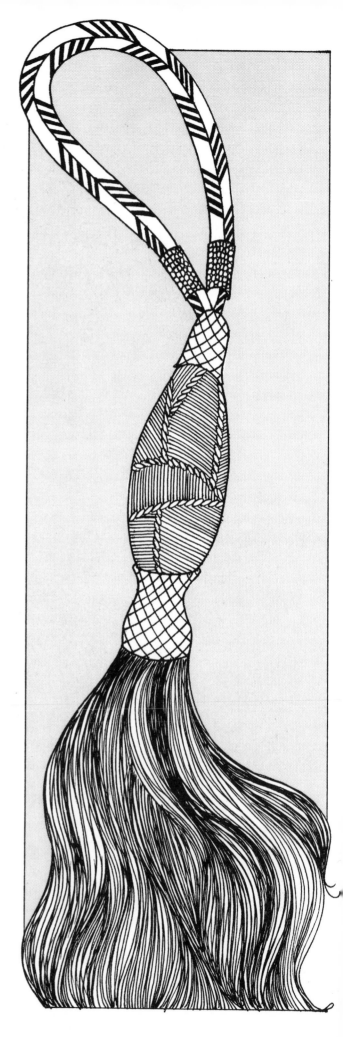

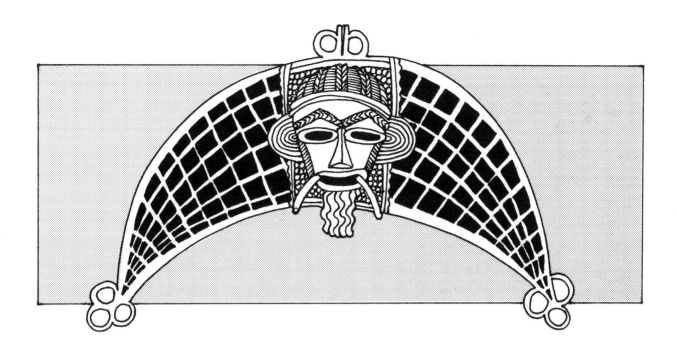

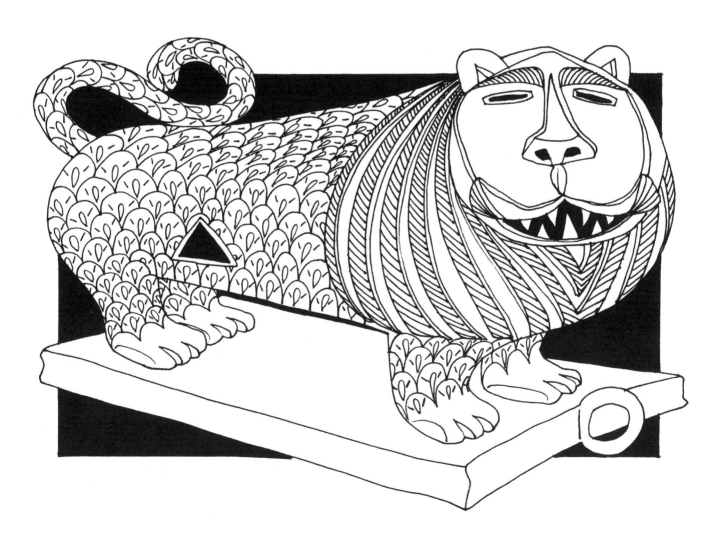

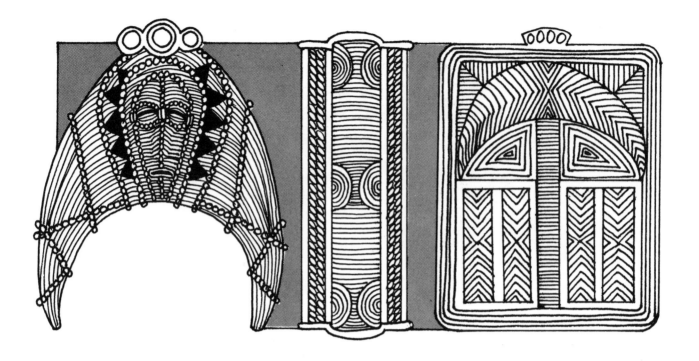

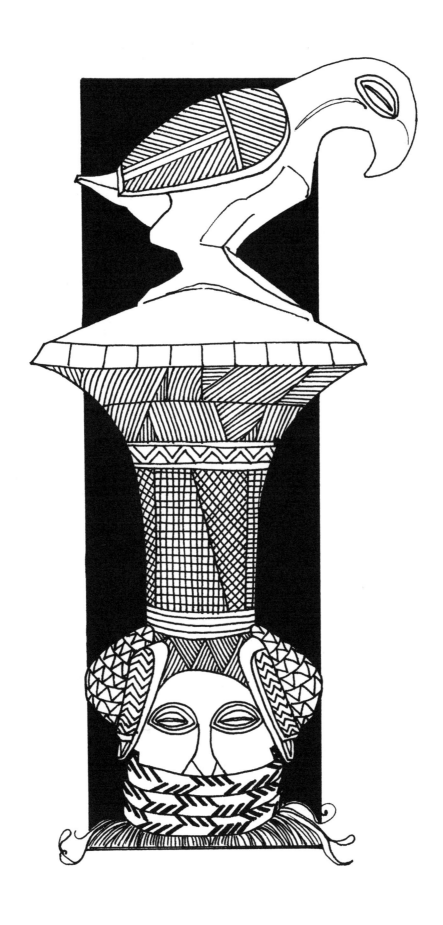

Designed by Barbara Holdridge
Composed in Times Roman by Brown Composition,
 Baltimore, Maryland
Cover color separations by GraphTec, Baltimore,
 Maryland
Printed on 75-pound Williamsburg Offset and bound by
 BookCrafters, Inc.,
 Fredericksburg, Virginia

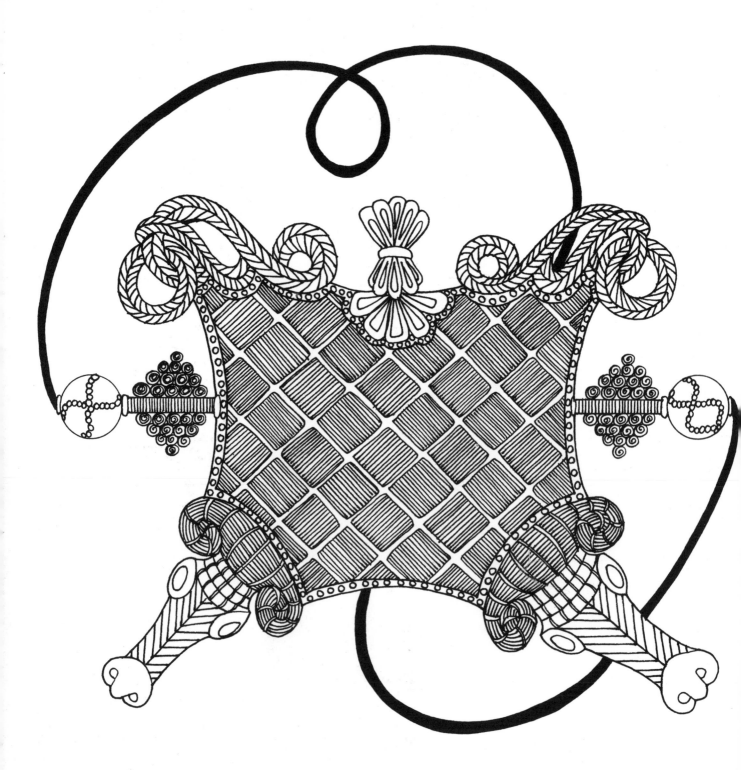